LOOKING
A Soul's Journey

To Kaylie.
Live Exceptionally

CHRISTOPHER L. JOHNSON

WINTERS
PUBLISHING
winterspublishing.com

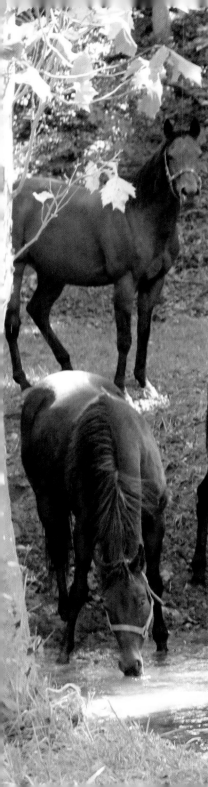

Looking — A Soul's Journey

Published by:
Winters Publishing
P.O. Box 501
Greensburg, IN 47240
812-663-4948
www.winterspublishing.com

Cover design by Rachel Winters
Interior design by Anthony Bitner, Tim Aldridge and Melissa Cohick

ISBN 10: 1-883651-53-0
ISBN 13: 978-1-883651-53-4

Library of Congress Control Number: 2012934913

Printed in the United States of America

Dedication

I dedicate this book to my mother, Connie. Without my camera, which she purchased for me as an early Christmas gift, this book would never have been possible. More importantly, not only did she give me life; but she has taught me much about "how to live." Whether it was falling down as a child or failing as an adult, she has always encouraged and supported me.

Without her (and my father, Glenn), I would not have reached a point in my life where "… raise up a child in the way he should go; and when he is old, he will not depart from it" is proving itself to be true.

Mom, I love you.

Dedication of the Equine Kind

Although my love for horses extends beyond any one breed, on our farm, Good Hope Equestrian Center, you will find mostly thoroughbreds, with a Quarter Horse or two, a Paint and even a Gypsy Vanner thrown in for good measure. It is the horses that have made the difference in me.

Retired thoroughbreds are often uncared for and unloved when their racing careers are over. Good Hope rescues horses from the track and provides care and love for these beautiful animals. Although we do not receive funds from The Thoroughbred Charities of America (TCA), the TCA raises and distributes money to charitable organizations in Thoroughbred rescue, retirement and adoption; research; education; and therapeutic riding programs. You can read more about TCA at www.tca.org.

In support of these majestic creatures of God, $1.00 of each book sale will be donated to the TCA. We thank you for your support.

Acknowledgments

There are so many people that I could acknowledge who were inspirational and motivational to me in compiling the material of this book. Some of you have kicked me in the butt when I need to get going. However, as I have seen this book become a reality, I have realized some of you have comforted me when I need a soft hand. Even if you are not specifically mentioned, you were essential to the process. To each of you, I say "thank you."

There are a few people that I would like to acknowledge specifically. I would like to thank Anthony Bitner, Tim Aldridge, Melissa Cohick and the Kokomo Area Career Center for the endless hours laying out the pages of this book. (Anthony and Tim, you will be brilliant in your future careers.)

Kristi Severns gave so many hours of her time reviewing pictures and reading my ramblings that became the words written in these pages. To all my students, who have inspired me to be better at all the things I do.

Keith and Rachelle Wexler gave me unlimited access to their horses and land.

And my son, Taylor, the true love of my life, surrendered hours with me and worked extra hours in the barn at times, just so I could work on this project.

If you read these pages, you'll know that all of nature—the dogs, horses (many of them retired and rescued Thoroughbreds from racetracks across America), creeks, woods—are the true "stars." And the God of the Universe, who created it all, "hung each of them" into their respective place just for me (and thus, for you).

Foreword

Christopher Johnson's book, *Looking — A Soul's Journey*, is an inspiring, beautiful and thought provoking exploration of his own inner world, illustrated through the world around him. By sharing his view through the lens of his camera and the written word, we are invited to explore our own inner struggles, hopes, fears and longings. He offers us questions to examine our own direction, or if you will, our journey. This intimate evaluation of his own life, poignant questions and insightful analysis stemming from moments in everyday life, will have the reader laughing, crying, questioning, and most of all, understanding more about themselves. Through everyday prose, he tackles complex psychological, theological and philosophical principles, while subtly encouraging introspection. I have shared many of his writings and pictures with my patients, who have been stirred and challenged to live life to its fullest; to savor each moment; and to appreciate the gifts that God has given. So, join him on this very personal, transforming experience; and above all, enjoy the journey.

Dr. Rachelle Steiner, MD
UCLA School of Medicine
Northwestern University–
School of Medicine–
Department of Psychiatry

When "Nothing" Meets "Everything," a Journey of the Soul Begins

Let's see, my life story would go something like this: born in a Midwest small town, clearly in the middle of the Bible belt; raised by two parents married to each other their entire lives; lived in a middle class home always with plenty of food and no physical abuse; high school athlete; Bible college and law school graduate; successful practicing attorney, college professor, and high school teacher—and, in the end, when I came face to face with who I was—it all meant nothing! When it appeared that I had everything, I had nothing.

But the story would also have to include: a childhood fraught with emotional and psychological neglect; years of rebellion against God and other authority figures; numerous failed relationships; struggles with deep depression and suicide for several years; and a withdrawal from almost all contact with people—and in the end, when I came face to face with who I was—it all meant everything!

At a point where I had the least to live for, I found a way to live differently than ever before. I began a journey of introspection, internal struggle and conflict resolution that has wandered through my emotional, psychological and mental landscape. It has left me feeling crushed under the weight of my past; exhausted from the battles of my present; and refreshed in anticipation of my future.

And I found the answers when I realized that the answers come from asking the questions.

I was raised to be ultra-competitive; and still strive to be the very best in all that I do; but there is a cost of success. Is "success" worth it at any cost? How much "success" is required to be "successful"? And, is "enough" ever "enough"? Before you even think it, let me be clear, I'm not espousing the values of apathy, slothfulness or a return to the "detachment from the establishment days" of the 60's. But, "chasing" success can be an endless, uncontrolled spiral into self-destruction and defeat. And, in our attempts to gain so much; we are in danger of losing our own souls.

I am convinced that the "journey" is more rewarding than the destination. The fact that we are on a "journey" is more important than having a goal or attaining the goal. Our souls need a journey of self-examination and discovery. A "journey" without a destination is not a "journey." Without a destination, we are left to "wander aimlessly" through life; and …

"Wandering aimlessly is the landlocked version of treading water and treading water is a prelude to drowning, unless we are rescued or learn to swim."

That principle is one I have learned and believe with all my being. And, where did I learn such a principle?

I found the answer through the lens of my "mind's eye."

Several years ago in the midst of all the chaos and turmoil of my life, I began to take snapshots in my mind and to focus on what was around me. It took seconds. That's all, seconds! I never took the time to ponder any significant thoughts as I "took" these snapshots; after all, I was too busy. But, I did experience a few fleeting moments where my brain stopped to appreciate what I had seen in my "mind's eye."

And then, my mother bought a camera for me as a present. I was able to capture what I had been seeing for several years. I could finally show someone, anyone, what I had seen with my "mind's eye." I began to record the thoughts which started when I saw something in the camera's lens; captured it; and listened to what my heart and mind had to say about the images. And from my "mind's eye," the words from my soul, and that camera came this book.

So, are you on a journey? Or, are you "wandering aimlessly"?

We must choose for ourselves. Circumstances may limit our choices; but we choose our own "journey." We must recognize that we are autonomous beings; and that our lives, our careers, our responses and the quality of our lives are not forced upon us; but chosen by us.

The destination is uniquely personal, originating from our "compass" that points us toward our "true north." That compass lies deep within your soul. It's what you truly value, and is determined by "who you are." It may be tough to find; and even tougher to admit once you do. I cannot find it for you; but I can hope to encourage you to find your destination.

In the process of taking pictures and writing, I've slowed the pace of my life internally; yet, it races around me. In that process, I have felt contentment in my soul for the first time in my life. And, let me tell you—it feels very good. Both my pictures and my words are almost an immediate response to some emotional stimuli experienced in my walks. And, if I had not taken the time to slow down to experience what was around me; I would have missed "movement in my soul, heart and mind" as designed by my Creator. And, I would have missed the chance to share those moments with you. There are many, many questions still to be answered; but I'm still looking for the answers.

Some of the pictures in this book have only a few words that go along with them. Others have several paragraphs. But, please experience the writing and pictures together. My pictures are not great by themselves and my writings are not the prose of Longfellow or Shakespeare. I'm not a professional photographer or writer. But in combination, I think they can be powerful in your journey to questioning your world and your existence in it.

Come take a "soul's journey" with me!

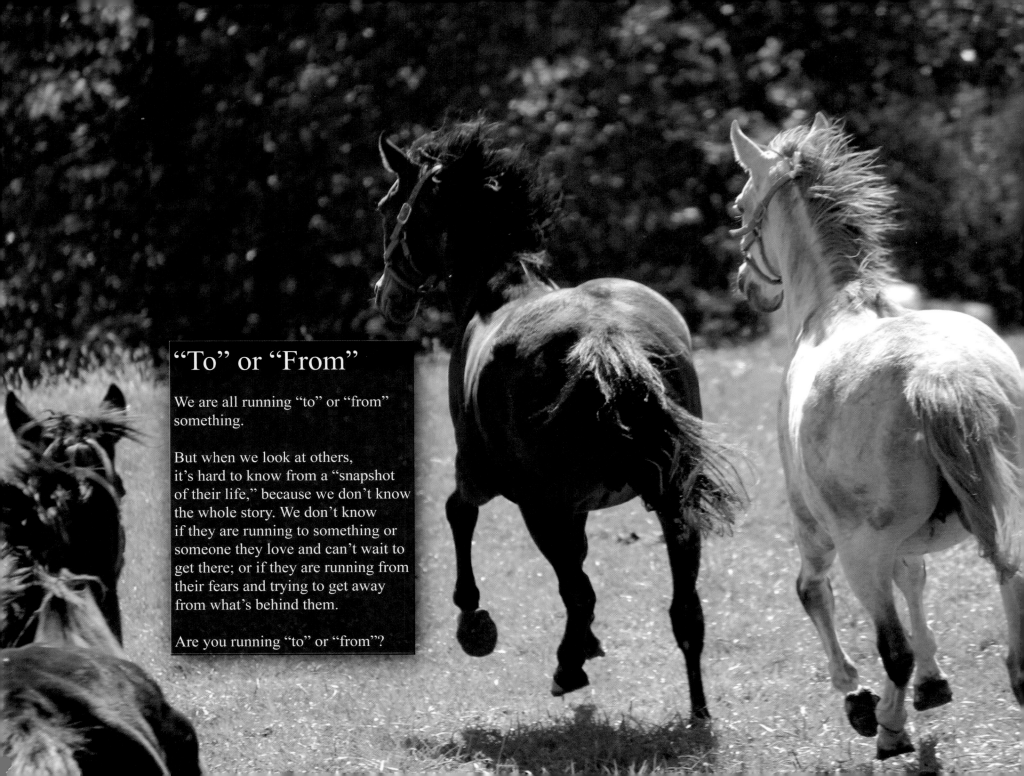

"To" or "From"

We are all running "to" or "from" something.

But when we look at others, it's hard to know from a "snapshot of their life," because we don't know the whole story. We don't know if they are running to something or someone they love and can't wait to get there; or if they are running from their fears and trying to get away from what's behind them.

Are you running "to" or "from"?

Single Leaf

Is it the weakest leaf that is left on the tree?

You know, is it the one that didn't have the guts to let go and follow "the lead" of the others around it?

Or …

Is it the strongest leaf that is left on the tree? Could it be that it held on through all the storms and winds; and will finally, on its own terms, decide its own fate?

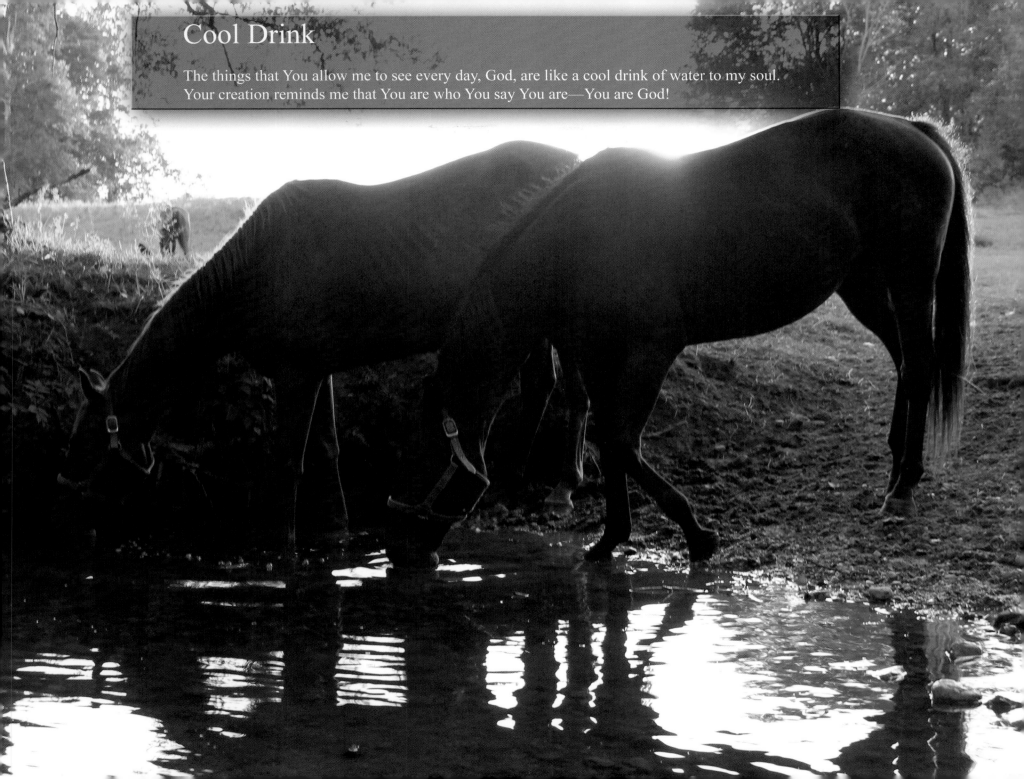

Cool Drink

The things that You allow me to see every day, God, are like a cool drink of water to my soul. Your creation reminds me that You are who You say You are—You are God!

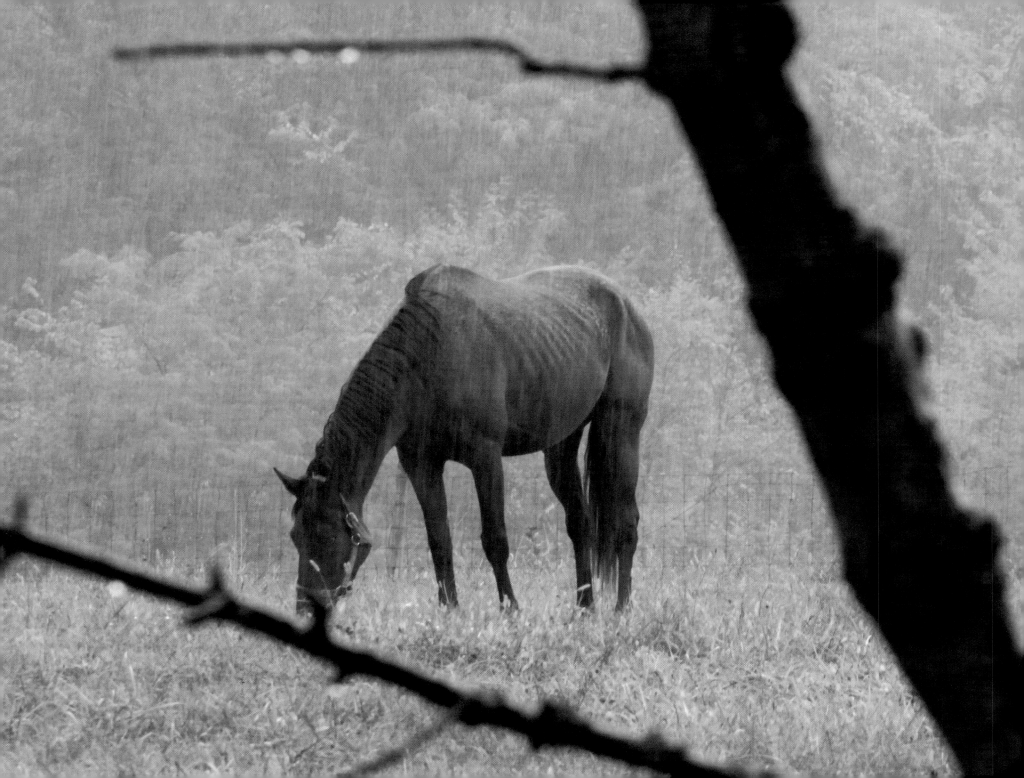

Alone vs. Lonely

Which is worse—being "alone and lonely" or being "with someone and being lonely"?

"Alone" is a fact—you are not in the presence of another human being. "Feeling lonely" is a normal emotional reaction to not sharing intimacy with another human being. Loneliness exists even in healthy individuals.

"Alone" doesn't have to be lonely. But, "being alone and feeling lonely" can become lifeless and hopeless. But as long as hope remains, the good news is that "lonely" is one step from being gone, even when we are alone. With the existence of hope, today or tomorrow might bring that person to lift loneliness from our lives by their mere presence. So, with the removal of "alone" external to us, "loneliness" disappears within us.

"Feeling lonely" and being with someone is empty, excruciatingly painful, and life threatening (not physical, but emotional death). Not only does it not have any "life giving" power in it; but it also sucks "life out of living" through the frustration of knowing that being with this person was supposed to have been the answer to being alone and lonely. And, in order to eradicate this loneliness from our lives, we have to go backward out of the relationship; in order to go forward to find "the absence of loneliness."

So, I'll choose "alone and feeling lonely." It's only temporary (even if it doesn't feel like it) and the answer to "loneliness" is within me first; and then, and only then, "non-alone and non-loneliness" can be shared with someone else.

Change of Perspective

Your perspective tells you what you see—either a tangled mess or a beautiful silhouette.

If you focus on the branches, you see a tangled mess. If you focus on the light, you see a beautiful silhouette.

Sometimes our hearts and emotions perceive "a mess"; but our brains and our thoughts can see something completely different.

Our hearts "feel" the situation in which we find ourselves; but our brains "know," or "should know" that we are there, often (not always), because of our own choices. Our hearts "feel" desperate and hopeless; but our brains "know" we can choose differently, and although not painlessly or easily, we can find our way out of those same situations by new choices.

Feelings need thoughts; as much as our hearts need our brains. Thoughts can imprison our feelings; so we feel no hope. Feelings can paralyze and cripple thought, so we see no means of escape.

Without both—emotion and thought—we aren't "living." And, if we aren't living, but aren't dead; we only "exist"—a slower version of dying.

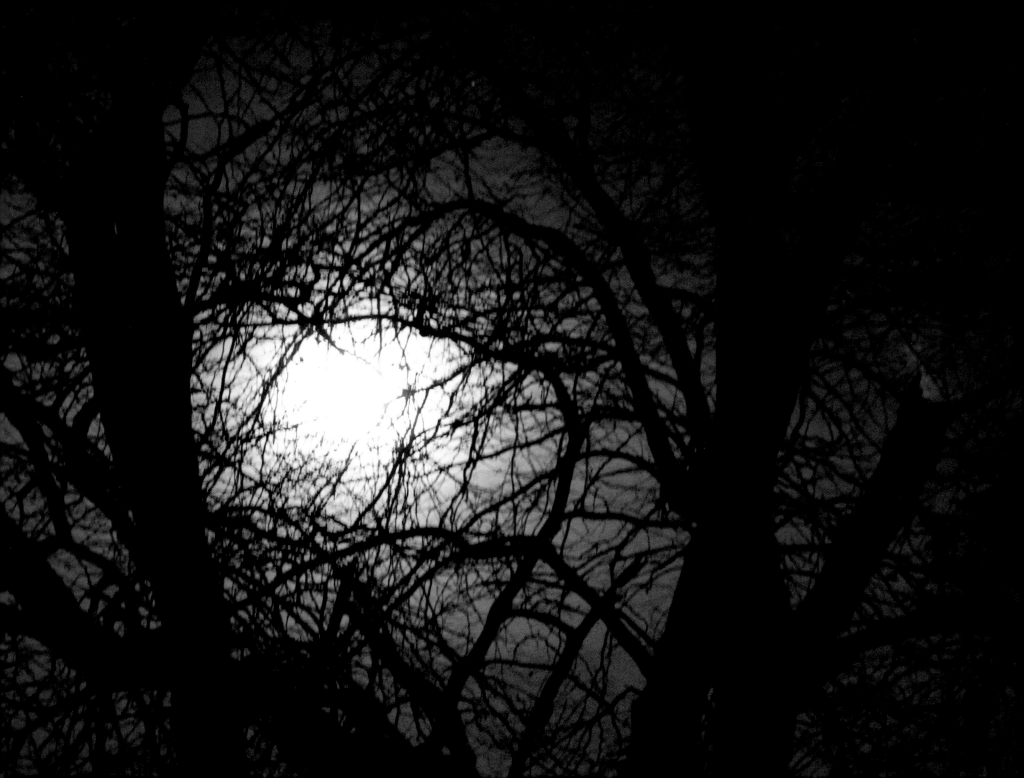

Shattered Dreams and Lives

It can be demoralizing and deflating when our dreams are shattered and we don't attain or obtain what we had hoped for; but when all the shattered dreams combine to kill the hope, we see shattered lives.

A missed opportunity or failed attempt is one thing; we recover from a shattered dream to try another day, because we still have hope in the future.
But to live without hope of another opportunity, because we believe we have failed too many times, leaves us with shattered lives.

We cannot repair the pieces of the shattered lives of others, just as we could not repair this tree and attach it to what gave it life. But, I do believe we have the ability to help restore hope to those around us who feel none.

Dance of Life

Ecclesiastes 3:3-5 (NIV) says, there is "… a time to weep and a time to laugh; a time to mourn and a time to dance …"

Even in mourning, weeping, or when life is "less than what we hoped for," there is life. We aren't "fully alive" only when we are happy, laughing, or everything is "just what we want." We are alive when we suffer pain, loss or sadness; as well as pleasure, gain and happiness.

Feeling the intensity of every emotion is proof of life. We are fully alive when we experience ALL that life brings us. When tears burn our faces like fire—we live, not exist! When our bodies ache every morning—we live, not exist! When we hurt to the core of our souls for others—we live, not exist!

As the Scripture says, "There is a season for everything."

I'd have never known heartbreak; if I hadn't been lost in love. I'd have never known missing someone; if I hadn't felt being "one with someone else." I'd have never known the pain of the death of a loved one; if I hadn't felt my child in my hands at his birth.

And, if we truly want to live life fully alive; then we must choose:

To not run from life—embrace it.

To not hide from life—confront it face to face and tell it "to come get me."

To not sit on the sidelines of life and watch the game—get in it.

Life has a purpose. It is to be lived; not endured or outlasted. Good or bad; alone or not; happy or sad; rich or poor; healthy or sick; I choose to suck every last drop of life out of every moment.

My dear friends—LIVE, don't exist!!!!!

Cowboy and Complaining Humans

Cowboy was lying in the aisle of the barn this morning, when I opened the door. I was half complaining and half talking to my dog (don't tell anyone), so I asked Cowboy, "You think it'll ever stop raining, old man?"

Cowboy has that "very wise, looking off into the distance, I'm a whole lot smarter than you, human" look about him most of the time. I often ask him questions; he dismisses me with a stare; and he goes back to looking off into the distance, as though the answers are written out there in a book that only dogs can see. But today, he had an answer right away. He said:

"Doesn't really matter, now does it? It's just another day filled with opportunities to make choices. You choose to go to work; and well, I don't! You choose to worry about the rain; and well, I don't. You choose to miss the wonderful sound of rain falling on a metal roof; and well, I don't. You choose to think about what you don't have, and well, yes, you got it, I don't do that either."

He stopped, stared at me and said, "You see a pattern developing here, human?"

He looked away again, but continued: "I've sat in barns all over and I always heard humans complaining about the weather, prices, horses, politicians, etc. You never hear dogs complaining, now do you? You want to know why?"

At this point, I didn't know whether to answer or not: but I stared back at him with a look that must have told him I was truly a "dumb human" and I needed his wisdom.

He looked at me this time and said, "Cause rain or shine; cold or warm; hungry or stuffed on table scraps; I choose to live every day for what it is—a gift from God."

I hate when my dog is smarter than me!

P.S. As I was walking away, I heard him clear his throat, as to say, "Uhhh, excuse me." I turned and he said, "I'd think that was worth a couple of biscuits, a pat on the head, a belly rub, and an 'I love you, Cowboy.'"

Smart dogs can be so demanding, especially when they can talk!!

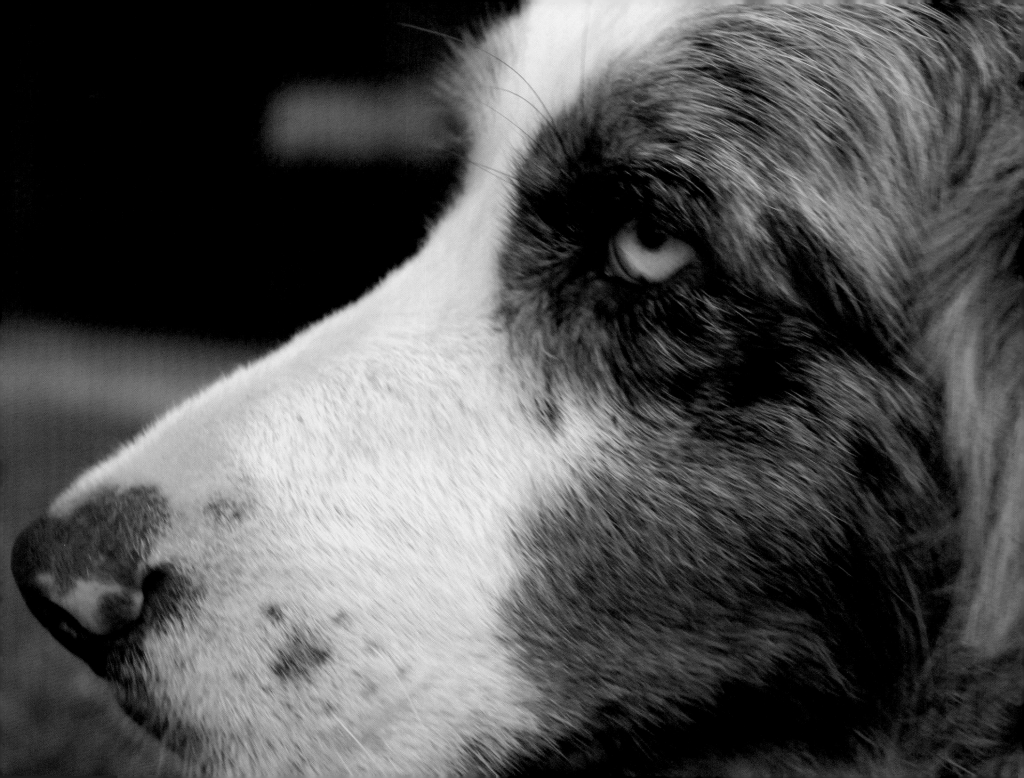

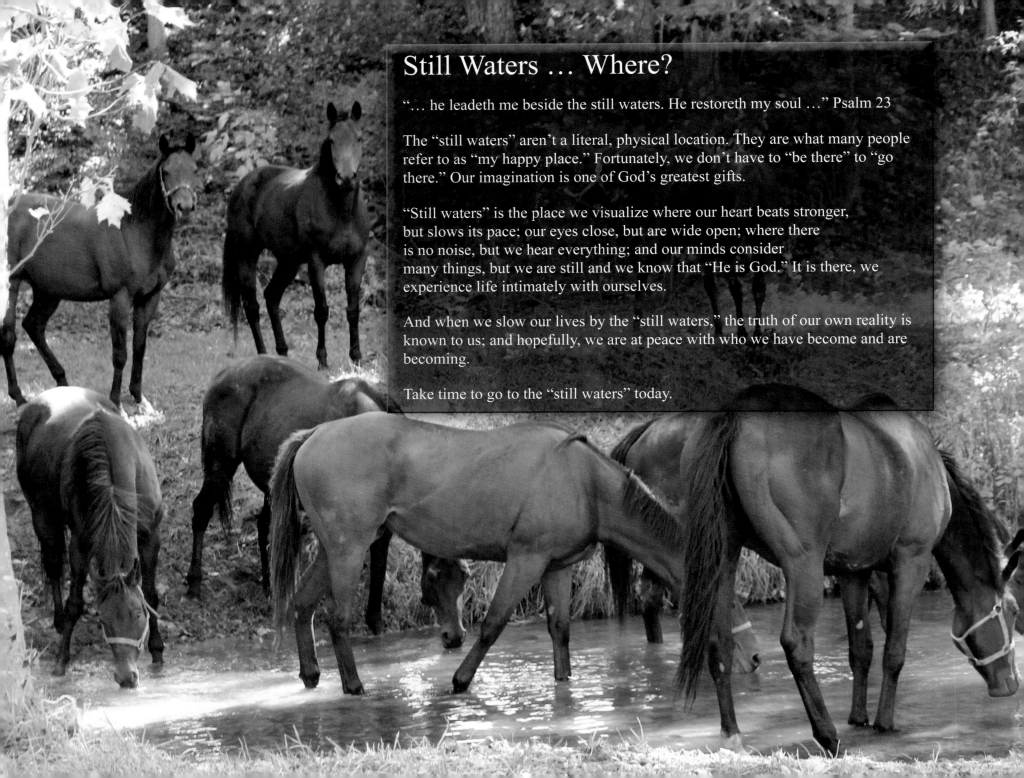

Still Waters … Where?

"… he leadeth me beside the still waters. He restoreth my soul …" Psalm 23

The "still waters" aren't a literal, physical location. They are what many people refer to as "my happy place." Fortunately, we don't have to "be there" to "go there." Our imagination is one of God's greatest gifts.

"Still waters" is the place we visualize where our heart beats stronger, but slows its pace; our eyes close, but are wide open; where there is no noise, but we hear everything; and our minds consider many things, but we are still and we know that "He is God." It is there, we experience life intimately with ourselves.

And when we slow our lives by the "still waters," the truth of our own reality is known to us; and hopefully, we are at peace with who we have become and are becoming.

Take time to go to the "still waters" today.

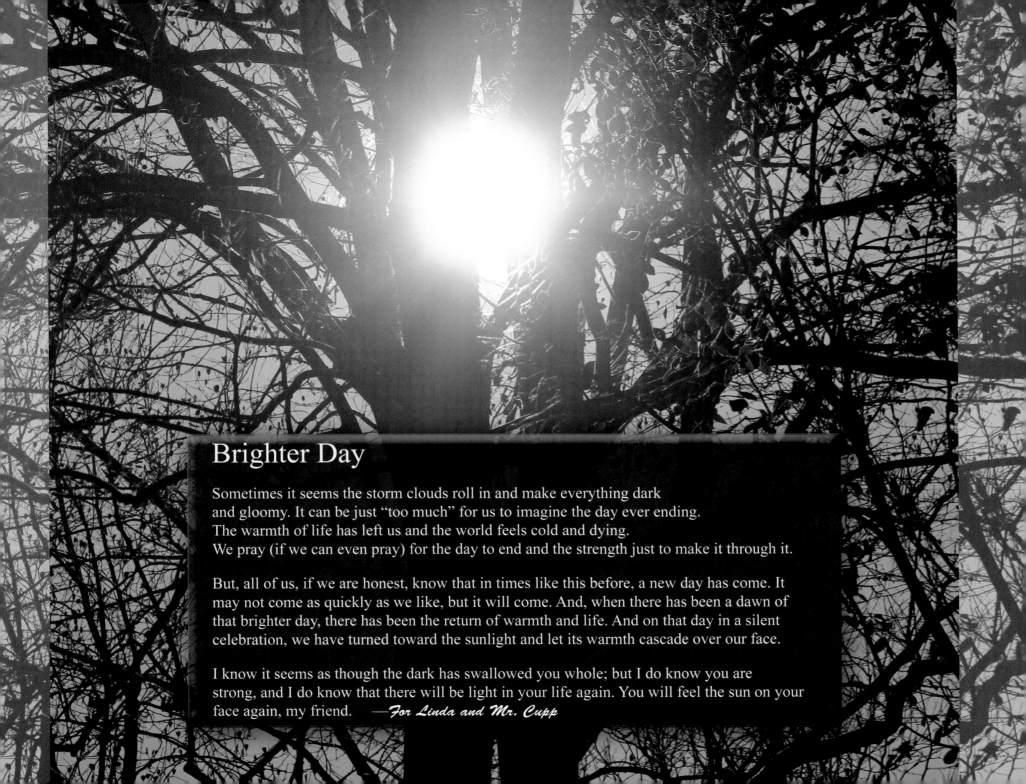

Brighter Day

Sometimes it seems the storm clouds roll in and make everything dark
and gloomy. It can be just "too much" for us to imagine the day ever ending.
The warmth of life has left us and the world feels cold and dying.
We pray (if we can even pray) for the day to end and the strength just to make it through it.

But, all of us, if we are honest, know that in times like this before, a new day has come. It
may not come as quickly as we like, but it will come. And, when there has been a dawn of
that brighter day, there has been the return of warmth and life. And on that day in a silent
celebration, we have turned toward the sunlight and let its warmth cascade over our face.

I know it seems as though the dark has swallowed you whole; but I do know you are
strong, and I do know that there will be light in your life again. You will feel the sun on your
face again, my friend. —*For Linda and Mr. Cupp*

Stop and Smell the Coffee

I'm trying to choose more often to stop and enjoy the moments of each and every day—you know, stop and smell the coffee (cause I hate the smell of roses).

There are so many little "happenings" around me that might seem insignificant as they occur, but are truly significant in the building of my life or someone else's.

I know there is so much life to be savored in everything around us; and I believe that every time we stop to "breathe in" a full breath of life, we restore our soul, renew our minds, and revitalize our hearts. We are one step closer to "fully alive" as a condition, not an event.

But sometimes, it seems as if life is going so fast; that the demands are so great; and the time is so short; that I'm paralyzed by the enormity of it all.

Fear

Franklin D. Roosevelt— "… the only thing we
have to fear is fear itself."

So, the question for me (I just share them with
you, who read my ramblings) for the day—
Do you think it's possible to be inexplicably
drawn to something we fear, or are we drawn to
the fear, itself?

I think we are often drawn to the idea of fear, the
intoxication of fear, the rush of adrenaline
(which is just fear rushing through our veins), more
than we are to the thing that we supposedly fear.
But, getting what we truly want often means that
we must face the fear and walk on through it to get
where we want to be or have the thing we desire.
For those of you who have never "gotten off the
bench" and into the game called "life," this will make
no sense. And, I'm sorry that you've never felt the
power that comes with living outside your comfort
zone where you often feel—fear. Fear that keeps you "on the sideline" is crippling. Fear that comes along with "living" is exhilarating.

Nature and animals teach us so much about ourselves. In many ways, they are a reflection of our own behavior. My Blue Heeler, Cinch,
was born to do one thing—herd animals by nipping at their heels. Unfortunately, he weighs 35 pounds and they weigh 1,100. But, even
though he is afraid of them, he can't wait to be afraid in close proximity to them. It's the fear (and overcoming his fear of fear) that
brings him closer to living as he was designed to live.

So, for me, I know I want the thing I fear the most, and I can't wait to get close to the fear every day. For each step closer to the fear
means one step closer to what I desire.

Stretch Ourselves

This drop of water, just like us on this earth, is only here for a brief moment. But in the short time

Shine your light while you have time!

Now look carefully!

The other droplets have not stretched themselves, so they remain dull and have no light to share although stretching itself out means that its presence will soon be over on this earth, it spread its

Our goal should be to redirect and focus the light that exists in people around us and within us.

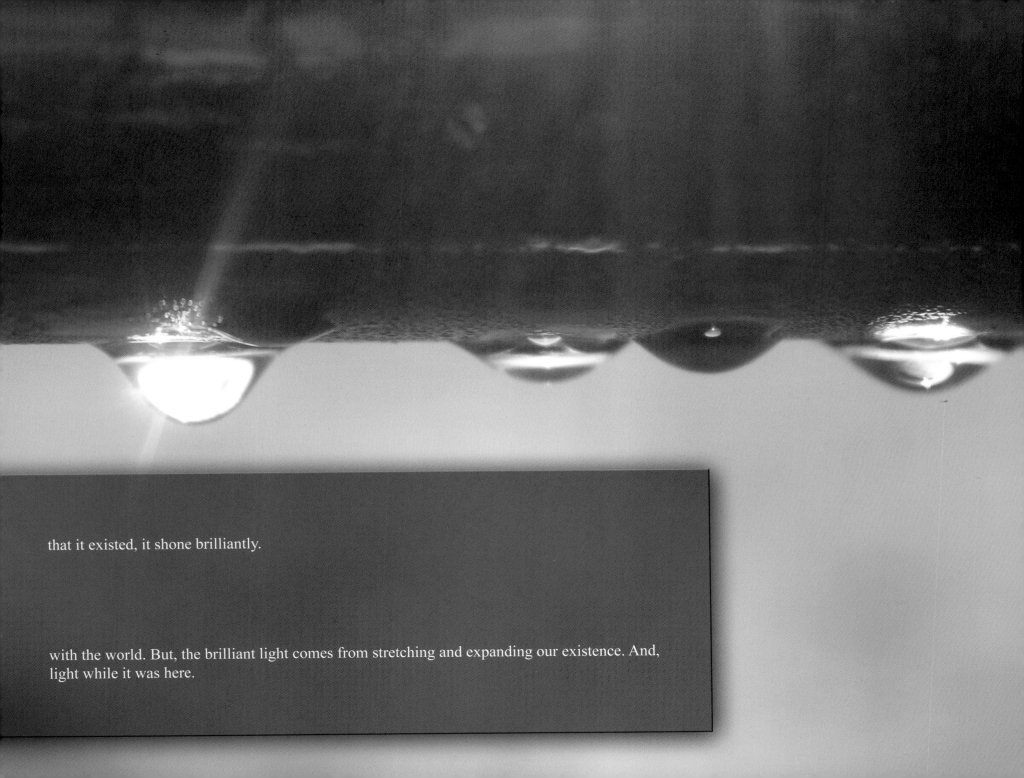

that it existed, it shone brilliantly.

with the world. But, the brilliant light comes from stretching and expanding our existence. And, light while it was here.

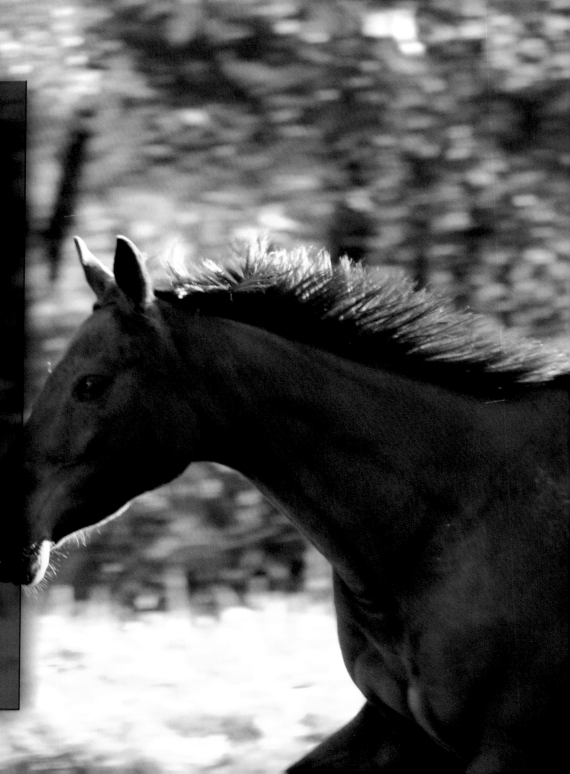

Enjoy The Moment

No matter how much running we do each day; or, no matter
how fast everything around us appears to be going; each hour
is a series of minutes; each minute a succession of seconds;
and those seconds are filled with individual moments.
It's what we do with each moment that matters.
We miss so much thinking about "after the first of the year,"
"next week," "tomorrow," or "in an hour."

The "movie" of our life (what everyone sees and remembers)
is nothing more than real-life animation created by "fanning"
the pictures of each moment quickly, so that it appears to be
moving. But just like the carefully crafted detail captured in
each frame of a Disney cartoonist's animation, there are the
incredibly beautiful intricacies of the "snapshot" of each
moment of our lives. I've realized that my camera captures
some of the visible evidence of each moment; but it cannot
capture the emotion of the moment—only my heart, my
"mind's eye," and my God-given senses can completely
expose the moment for all it is.

We just have to slow down long enough to see the beauty of
each moment. Portraits can record them, but life is not lived in
portraits. It is experienced frame by frame. And, if we can slow
our minds, our eyes, our ears and all of our senses to appreciate
the precious, fleeting nature of each moment—then we "see"
all that each frame offers. And, when combined with all the
other moments, the "movie" of our life becomes a masterpiece
in cinematography that "moves" within and affects others.

Live and appreciate each fleeting moment! Each comes
so quickly and is gone forever, never to be repeated.

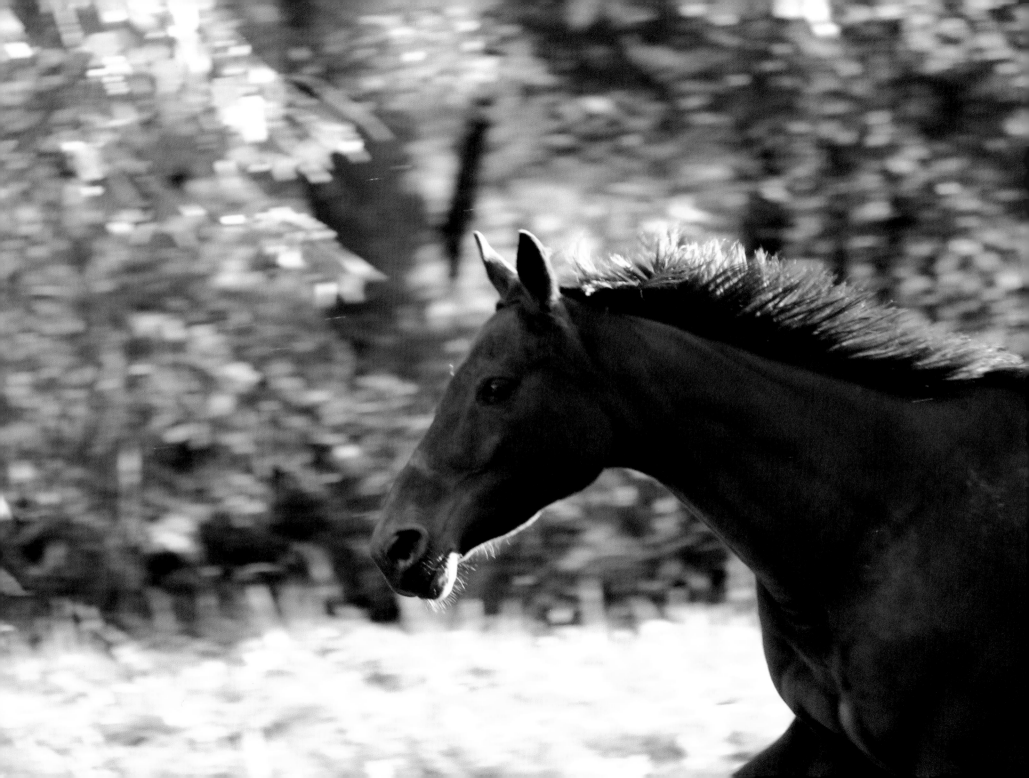

Loner

There is nothing wrong with being a loner.

If I want to be alone, let me! My need for solitude is no different than your need for socialization. Maybe, just maybe, I find comfort in quiet serenity. And, while you may need others to "energize you," I might need the absence of others because I feel drained by their presence.

'They' say, "There is strength in numbers."

I say, "There is strength in none." (Think about it before you react to it!)

If I gain strength from you, then I am dependent on you.

If I find strength in myself, then I feed my soul from within.

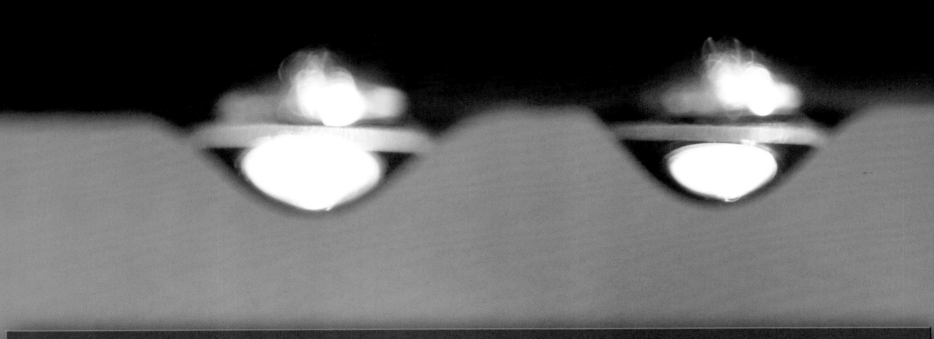

Company of Another

God said, "It is not good for man (or woman) to be alone."

In the core of our soul, divinely designed by our Creator, we long for the company of another person who understands us; supports us; encourages us; shares the same light that we do; and loves us.

If you have that person in your life, tell them how much they mean to you; and if you don't, never settle for anything less.

They and Cowboy

I've watched Cowboy lying in the grass on a warm day, just looking off into "somewhere" so many times. He's my dog, so I love him; but everyone loves Cowboy! Just something about him that makes everyone love him.

What you can't see in the picture is that Cowboy has three legs—lost one chasing a truck. With his three legs, you'd think that he might have resigned himself to a life less than if he had four legs. But, he's never seemed to care. He has never stopped running and playing. And most importantly, he has never allowed his condition to affect who he is. His dignity has never left him.

Over the years, I've found myself admiring his ability to remove himself from the activity of the farm and just enjoy life. While life rushes around him and humans around him seem to "chase their own tails," he seems to observe and be amused by the actions of others.

I don't know if dogs worry about what's for dinner; if they get into arguments with other dogs; or if they feel guilt or regret. If they do, Cowboy has learned to handle it all as just part of the day, and accept life. And if so, he is much wiser than the humans upon whom he seems to depend daily.

And if they do not, then I think that they have found the secret of living.

No worry! No strife! No guilt! No regrets!

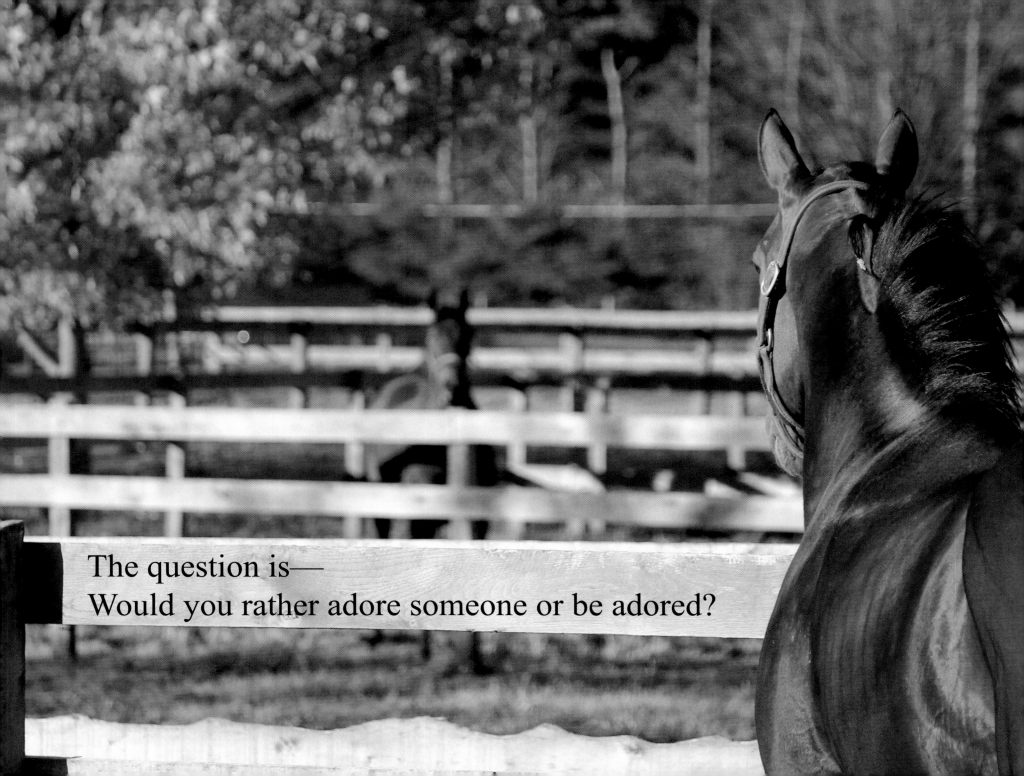

The question is—
Would you rather adore someone or be adored?

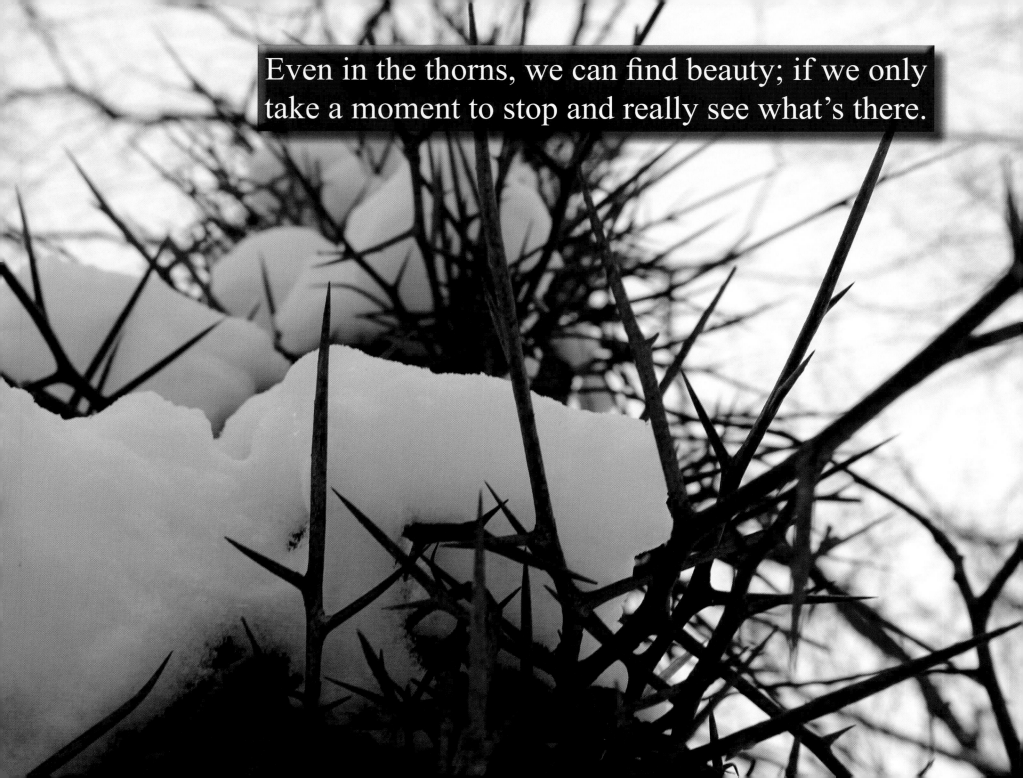

Even in the thorns, we can find beauty; if we only take a moment to stop and really see what's there.

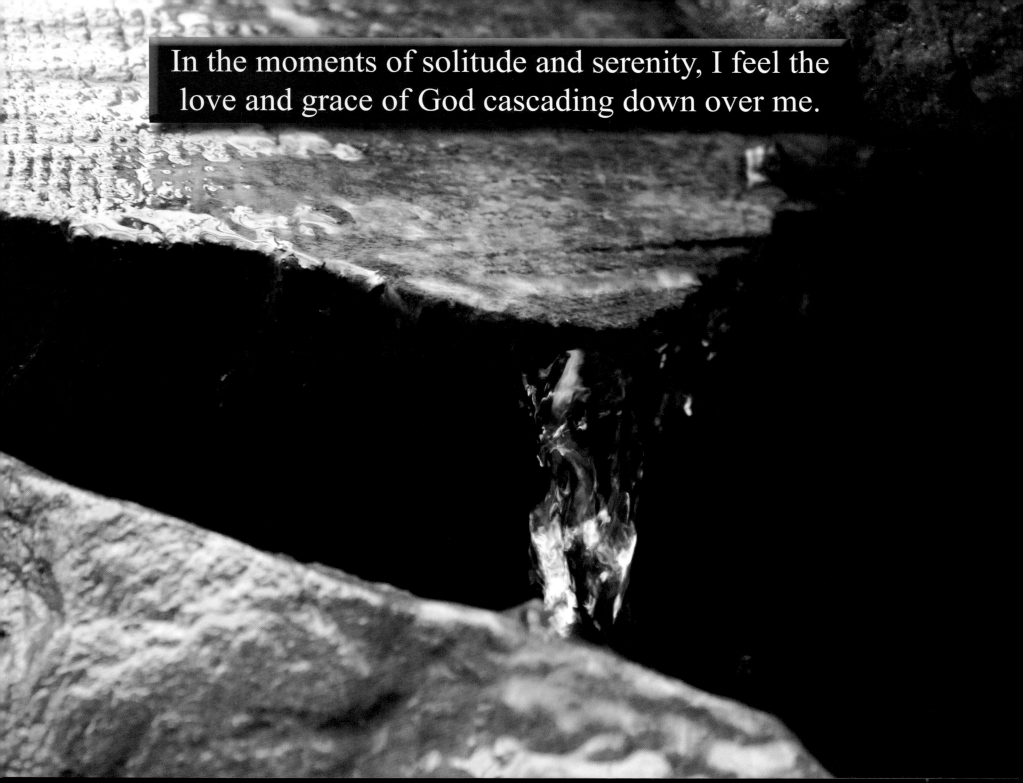

In the moments of solitude and serenity, I feel the love and grace of God cascading down over me.

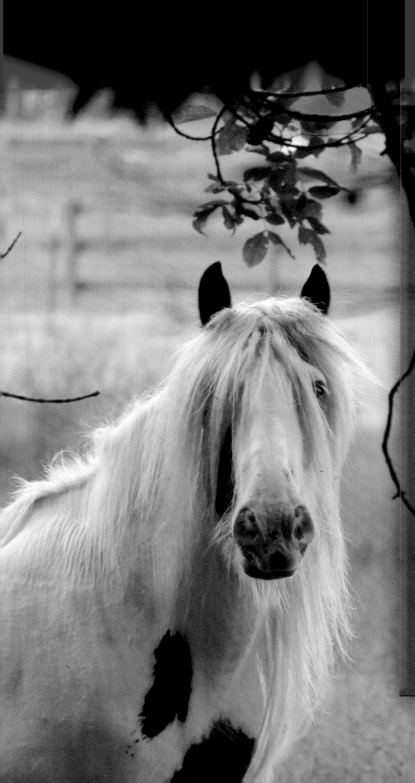

I Am Different (Shandor's Prayer)

I look different … but I am beautiful nonetheless.

I act different … but I will never lose my individuality.

I walk different … but I move with effortless grace.

You judge me based on your definition of "normal."
I neither judge you, nor want to be judged. Your
uniqueness is as obvious as mine. And I have learned,
because I am different, to appreciate the differences of
the world around me.

You think I stand and watch you; but in reality, I am
standing still so that you may have the chance to admire
my beauty; appreciate my individuality; and recognize
my grace. I am no better and no worse than anyone; but
I value myself for who God created me to be.

(I think we have a lot to learn from Shandor.)

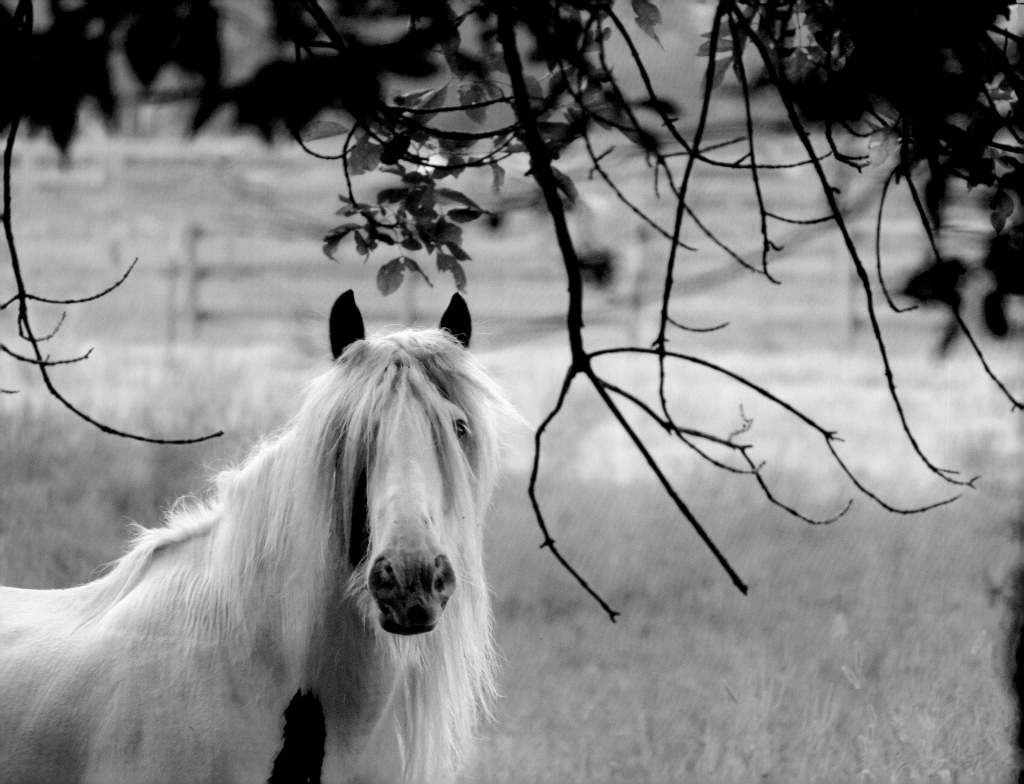

Companionship

Don't we all long for that one person,
who will share their life and our life in
such unity and harmony that their company
is like a cool drink of water on a warm day?
A person that when others see us together,
they see "two" that almost appear to be "one,"
without losing our sense of individuality. And,
when we look at ourselves in the mirror, we do
not see only ourselves, nor only the other; but
we see a reflection of the other and ourselves.

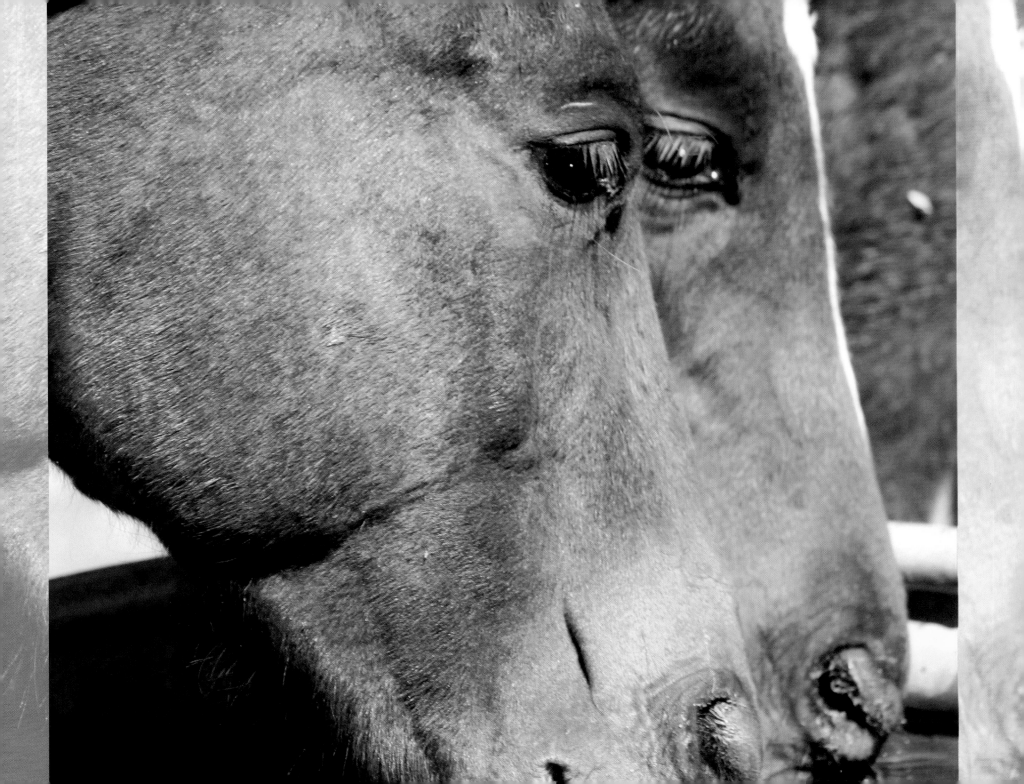

My Mind's Eye

Do we see what we love? Or, do we see what we are worried about? Or, do we see beyond the immediate and see the hope of the future? Or, have we reached a new perspective, and see and appreciate it all?

If all I care about is the "relational," my "mind's eye" only sees Cutter, who I love; but I can become obsessed with what he might need or want.

If I'm fussing about "work"; my "mind's eye" sees the missing board in the fence that needs to be replaced, but I miss the "relational" and the "beauty of today."

If I'm focused too much off into the future, I miss "the relational" and "the responsibility"; and I'm not living today. I'm just "dreaming" my way through life as I miss it all.

But, if my soul is "content," my "mind's eye" sees the whole picture. My soul allows me to see the "relational," the "responsibility," and the "hope." None greater than the other; but in a perfect blend, like a fine wine, that allows me to savor the full flavor of my life, as I drink it in every day.

What do you see with your "mind's eye"?

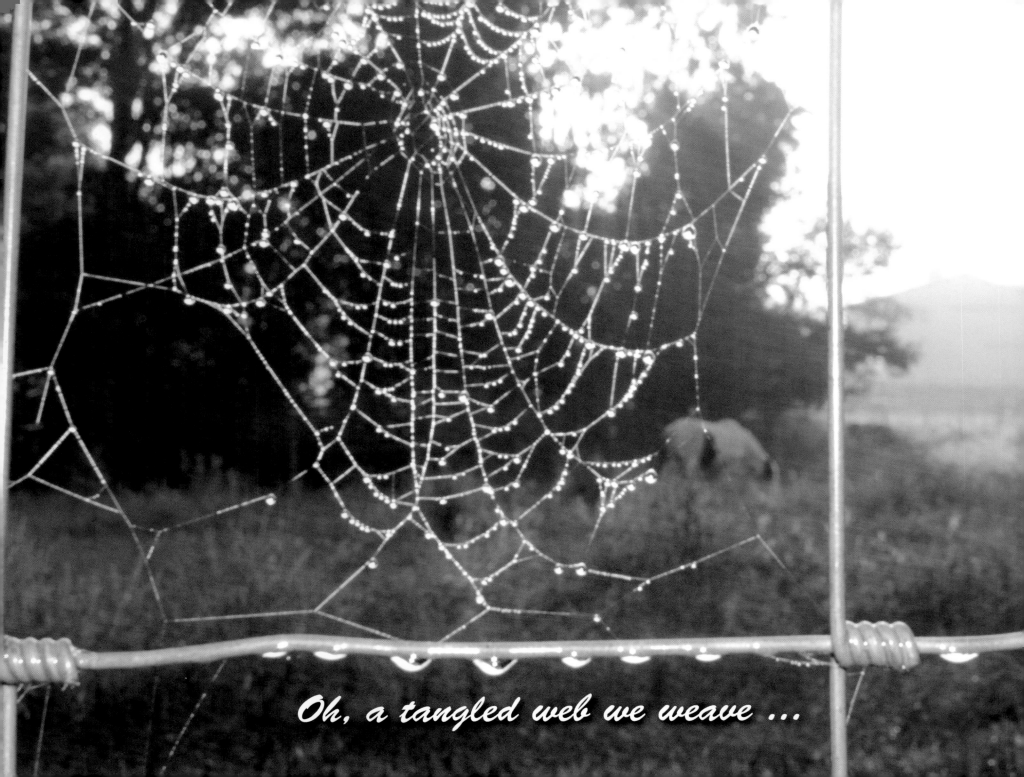

Oh, a tangled web we weave ...

Compass

Inside all of us there is a compass that directs our souls in their search for meaning. The kind of "meaning" which comes from knowing where we are going and what we will have accomplished when we get there. That compass sets our "true north." That place where, no matter how lost we may be, we find our direction again.

What we don't really realize is that the "compass" determines the destination. Who we are in our souls will determine where we would want to go. A person who believes in "a higher power" cannot desire the same destination of a person who believes the highest power is he/she. Their respective versions of "true north" are fundamentally inconsistent.

Our compass will find "north" every time. It points us in the direction and tells us how to get there by keeping our path true to our destination.

The rhythm of a gentle rain falling on the metal roof of a barn accompanies the harmony of life that exists within the soul of a man.

Synchronicity

Aren't we all just looking for the perfect "synchronicity of life" with one other person?

Those who have it and share it with someone should be grateful.

Those who have someone; but don't have it, will mourn its absence.

And, those who have no one continue looking for it.

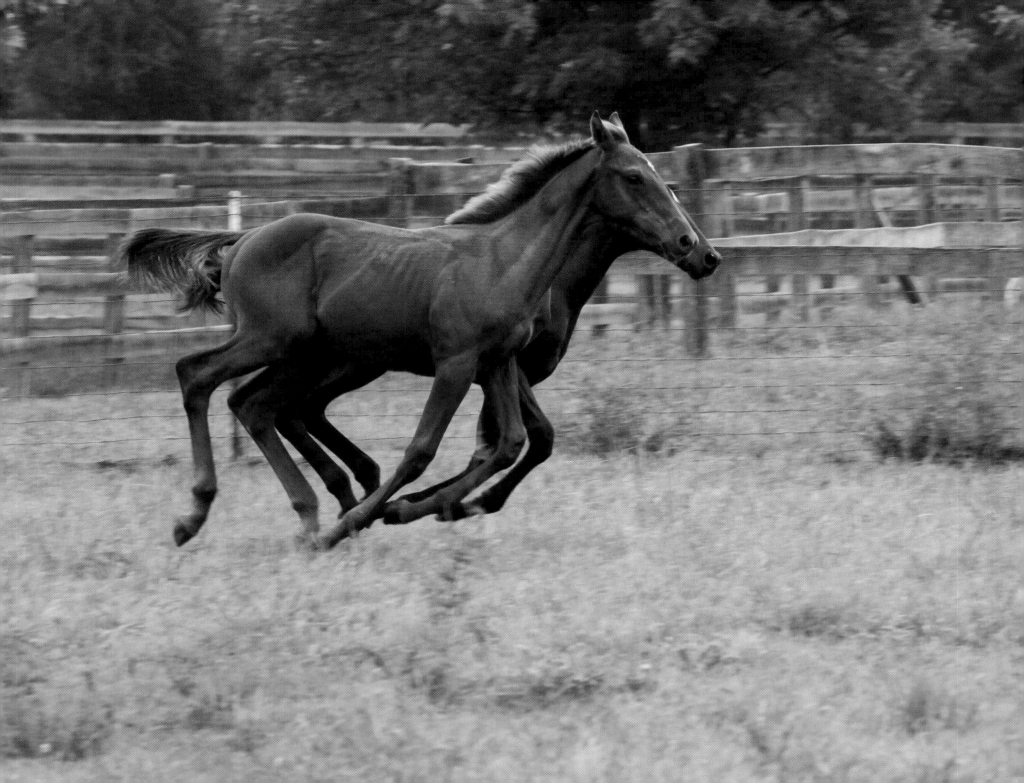

If you read about "they" today; then this will make more sense. One of the things "they" have always said to me is, "You need to go to church every week." And I agree; there is great benefit in church.

But, when you drive to church today; thinking about all you have to do this afternoon; but you bypass the perfect picture of God's creation along the way—Or, when you are supposed to be singing and worshiping; but you are worrying about what's for dinner—Or, when the preacher is talking about "loving others"; but you were gossiping last night—then I say, "You need to stop a minute and take a look at all around you that's beautiful; recognize that the Creator of the Universe, the One who gives you life, and the God who cares about you, made all of it for you to enjoy."

Maybe, God's message for you today will get through.

I leaned on the fence this morning; lowered my eyes and raised my head in awe, gratitude and worship of what God made for me and allowed me to share this morning.

Believe me, I was in church—God's church has no walls. God's church is in your soul, not in the pew!

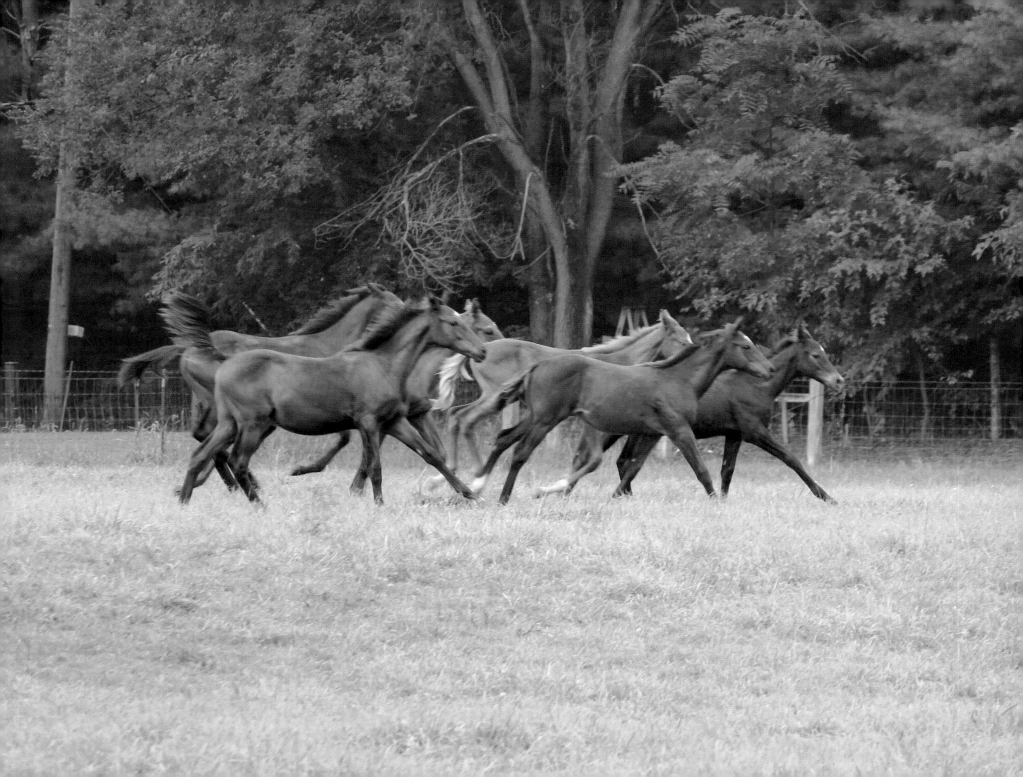

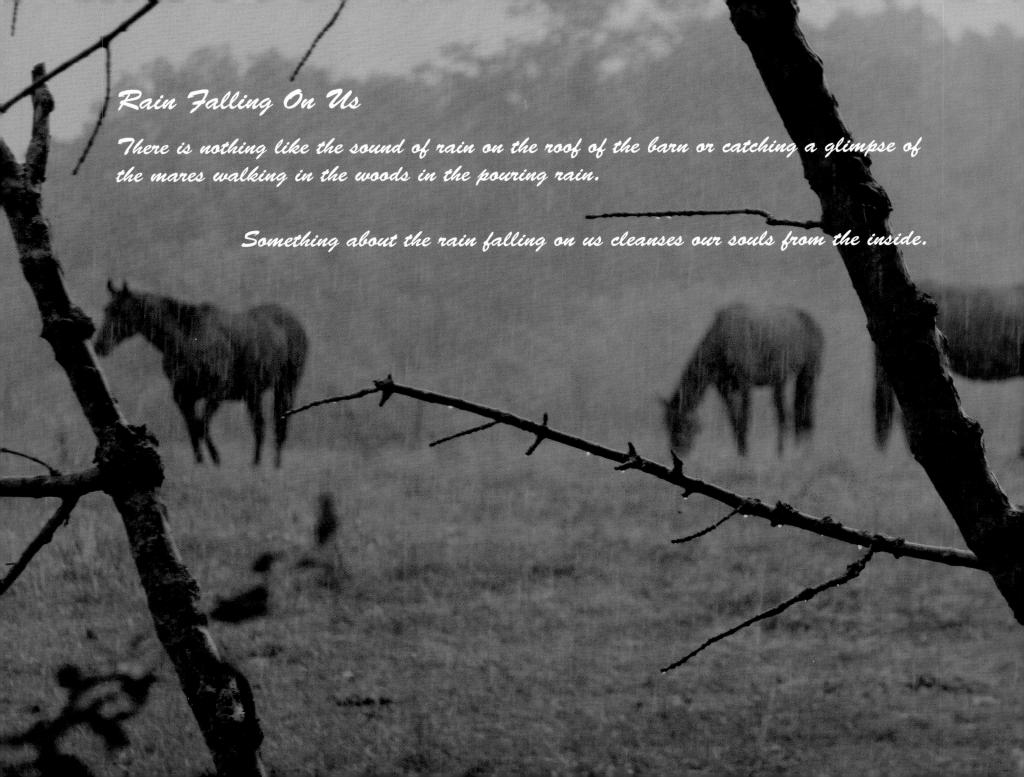

Rain Falling On Us

There is nothing like the sound of rain on the roof of the barn or catching a glimpse of the mares walking in the woods in the pouring rain.

Something about the rain falling on us cleanses our souls from the inside.

Torn Up

Even when someone has been all torn up by life; it doesn't mean we should discard them.

Recently, I had a student break down in front of me. He was beaten and battered by life. To my own shame, I just thought he was "strange."

We see the physical injuries in others so easily; but hopefully, we slow down enough and walk with an awareness of others, so that we see the "torn up pieces" of their hidden injuries.

KIDS

Just like colts and fillies, kids are unfinished products.

We raise and train thoroughbreds to do one thing—run, run as fast as they can. But, the big, strong, graceful ones as babies, often can't "run a lick" as adults. And, sometimes, the ones with crooked legs, funny ears, and clumsy feet can be real winners when they grow up.

Whether it's the frustrating kids in our own homes; the ones in a classroom; the ones who visit your business; or those kids that drive you crazy in your neighborhood— remember, they are unfinished products waiting to grow into their own skin. They need guidance and direction (aka training), just like our babies on the farm.

And, if they are like many that I deal with every day; just remember—that boy, with sagging pants and a crooked hat; or that girl in all black clothes and makeup; or that kid, who just has a bad attitude; may have no one in his/ her life that cares about him/her enough to show any love and/or recognize they have wounds we cannot see.

Forest Forgotten

We often get so focused on what's immediately in front
of us, we miss the beauty of what's just beyond it.

Looking

So many days, I know I have something to say and it comes flowing out. Other days, I have something on my mind, but it takes a long time to find the words to express my thoughts.

And then … there are days like today.

I know I'm "feeling something." I know I have "something on my mind." And, I believe that it's something that's worth knowing; and then, saying. It's strong; but, I don't even know what it is. I can't find it "in there." Maybe, it's an answer to a question that I've been asking for a long time!

I'm still looking …

Lost Art of Friendship

It seems to me that friendship is a lost art. In a world of "Facebook friends," "friend requests," "bff's," and TV shows called "Friends," we've forgotten that friendship is a privilege, not an expectation. It can bring so much joy; and yet, so much pain.

But, regardless of how strong or how close a friendship may be; sometimes, it ends because it has reached a point where it can go no further. And unfortunately, that's not enough. Nothing wrong with the one who wants more, or with the one who is satisfied with the status quo. It's a matter of just not fitting right now. And so, one has to walk away.

And sometimes, friends can't do anything to make it better. What they "don't say" is more important than what they "do say." What they "don't do" is sacrificial and loving much more than what they "could do." Sometimes when the right words or right action might be significant, not saying or doing anything is actually saying and giving so much more. Doing nothing is really doing everything! It is the last sacrificial gift to the friendship.

And, a friendship that reaches this kind of conclusion (temporary or not) really does not end; if it is real, it is only suspended in time. The memories are frozen and do not grow; but they remain fresh in our minds and do not wither away.

A true friendship never dies!

Sounds of Hooves

Sometimes—regardless of the time of day, the place I may be at the moment or the circumstances around me—I am transported to a place of peace and contentment. When I close my eyes and open my mind, I can hear the sounds of their hooves coming to greet me.

For those who love these incredible beasts, the sounds of their hooves in our ears are imprinted on our hearts and souls. Today, God, I thank You for Your infinite wisdom, grace and love in creating—the horse.

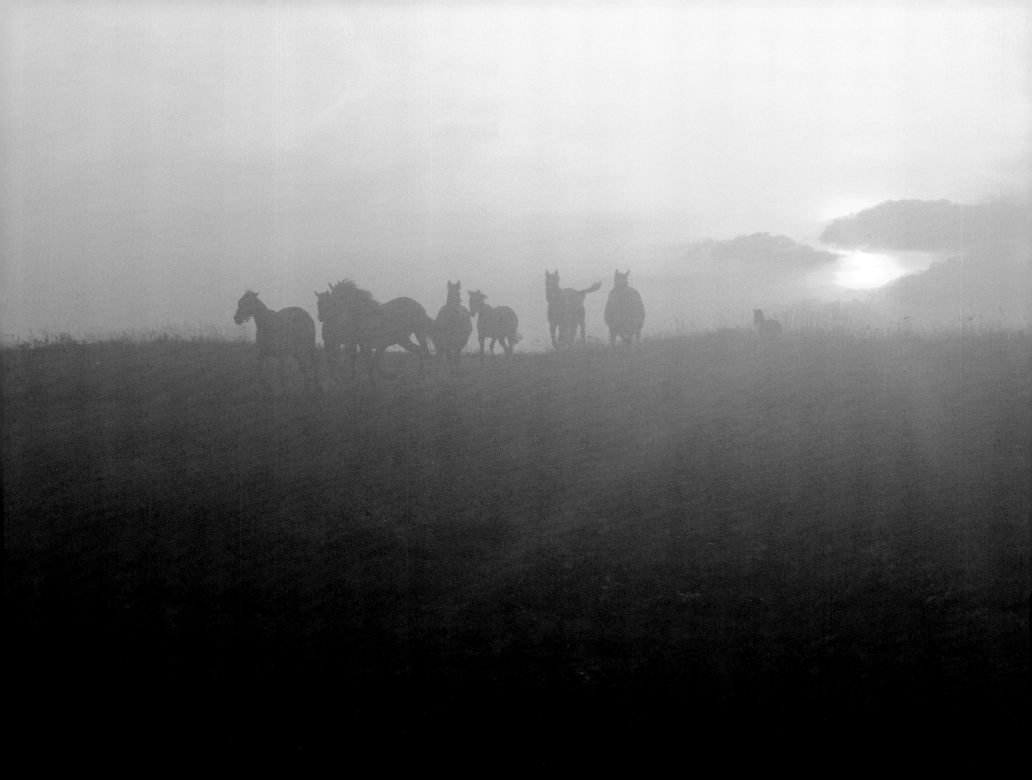

Someone to Inspire

We all have special people in our lives; but hopefully, we have one or two who have made a real difference in us as a person—who made an indelible impression on our development in becoming who we are and will become—who left a memory of them etched in our minds that will never be forgotten.

I would hope and pray that I would aspire to be that kind of person in at least one life, and that I never stop trying to "see" that person around me who is searching (even if they don't know they are) for "that person" in their life.

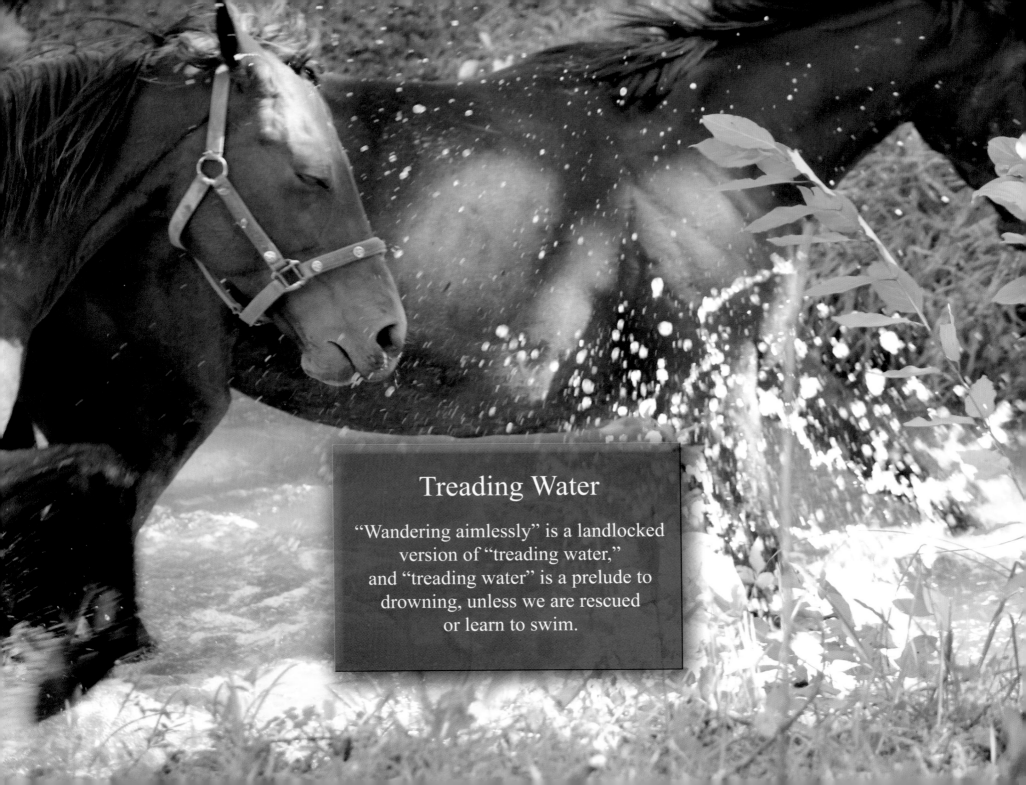

Treading Water

"Wandering aimlessly" is a landlocked
version of "treading water,"
and "treading water" is a prelude to
drowning, unless we are rescued
or learn to swim.

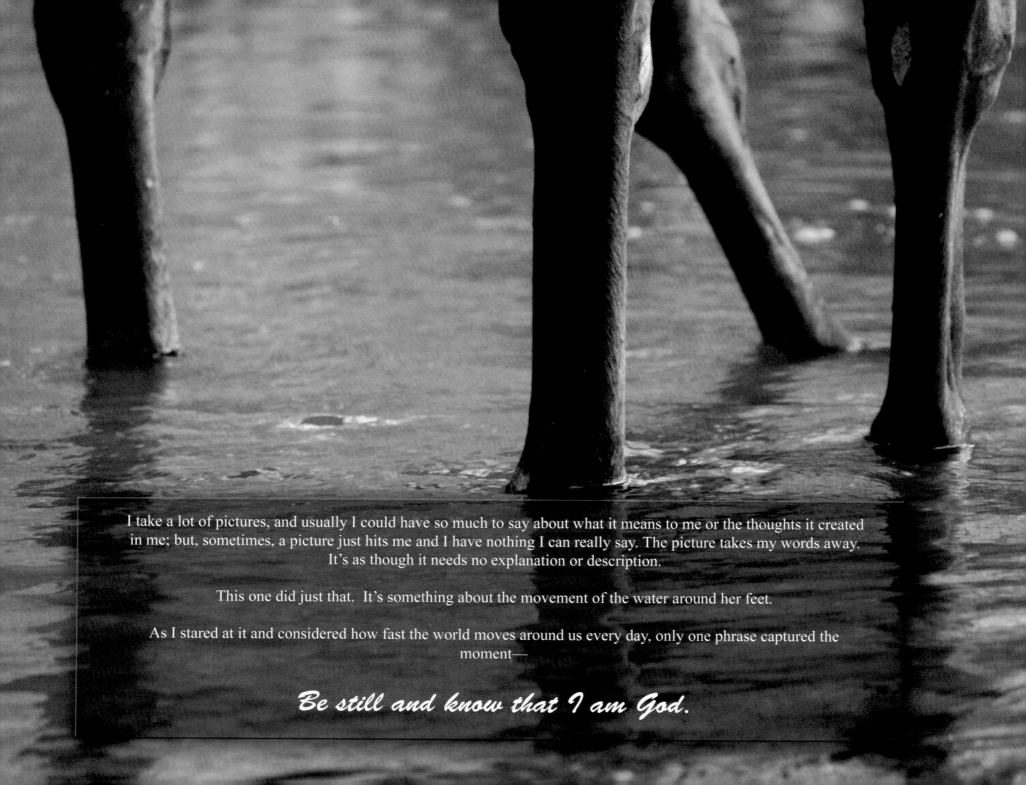

I take a lot of pictures, and usually I could have so much to say about what it means to me or the thoughts it created in me; but, sometimes, a picture just hits me and I have nothing I can really say. The picture takes my words away. It's as though it needs no explanation or description.

This one did just that. It's something about the movement of the water around her feet.

As I stared at it and considered how fast the world moves around us every day, only one phrase captured the moment—

Be still and know that I am God.

Careful About What You Are Wanting

(One day out in the pasture)
Cinch (my Blue Heeler): "Dad, the mares aren't coming in as fast as they should. Want me to go up on the ridge, find them, and bring them home? Please, please, please, let me. I never get to chase them without you yelling at me. I'm ready, really, I am. This is what I've been wanting for so long. Come on, please, Dad. Please, I want this more than anything."

Me: "OK, buddy, go get them! Bring 'em down here where they belong."

Cinch: (On a dead run with his "happy face," he heads up over the ridge with not a mare in sight.) "Oh, boy! Oh, boy! I get to be a Heeler today! This is better than getting your belly rubbed and table scraps. I know I can do this. I've wanted this all my life."

He disappears for a few seconds and I can hear the thunder of their hooves rumbling in the silence long before I can see them. And, then …

Cinch: "Oh, nnnnnoooooooooooooooooooooooooo!!!!!! What was I thinking and what have I got myself into? These women" (how appropriate that they are all women and he's a male) "are going to kill me."

What are you looking for that you might not really want/need to find?

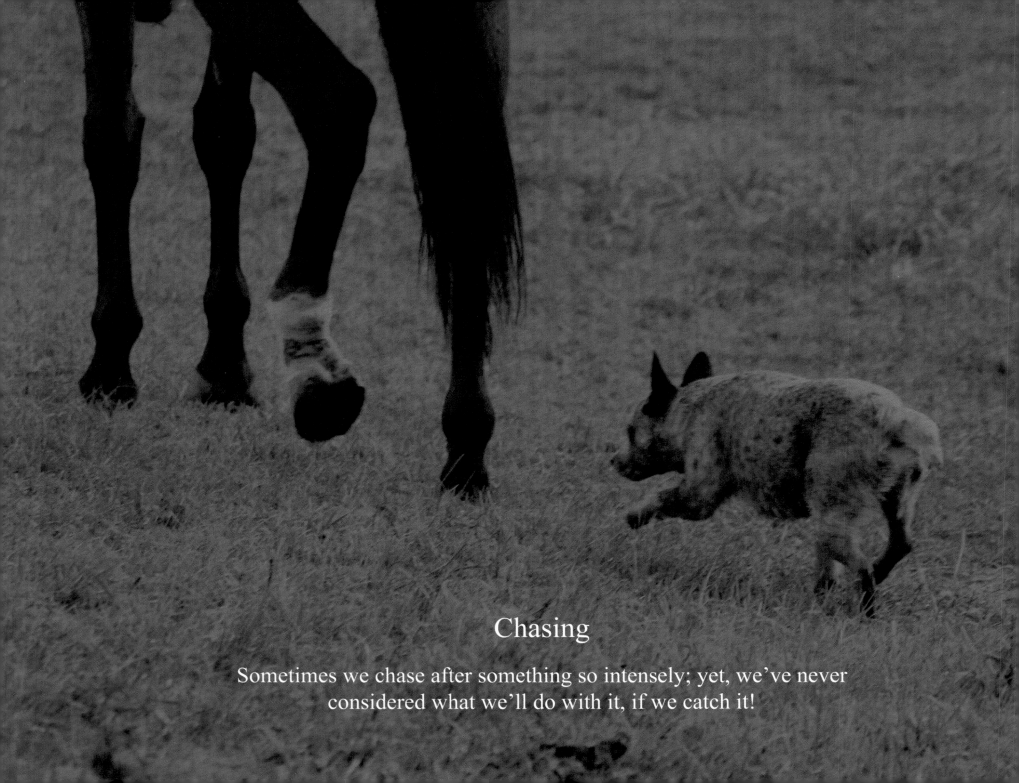

Chasing

Sometimes we chase after something so intensely; yet, we've never
considered what we'll do with it, if we catch it!

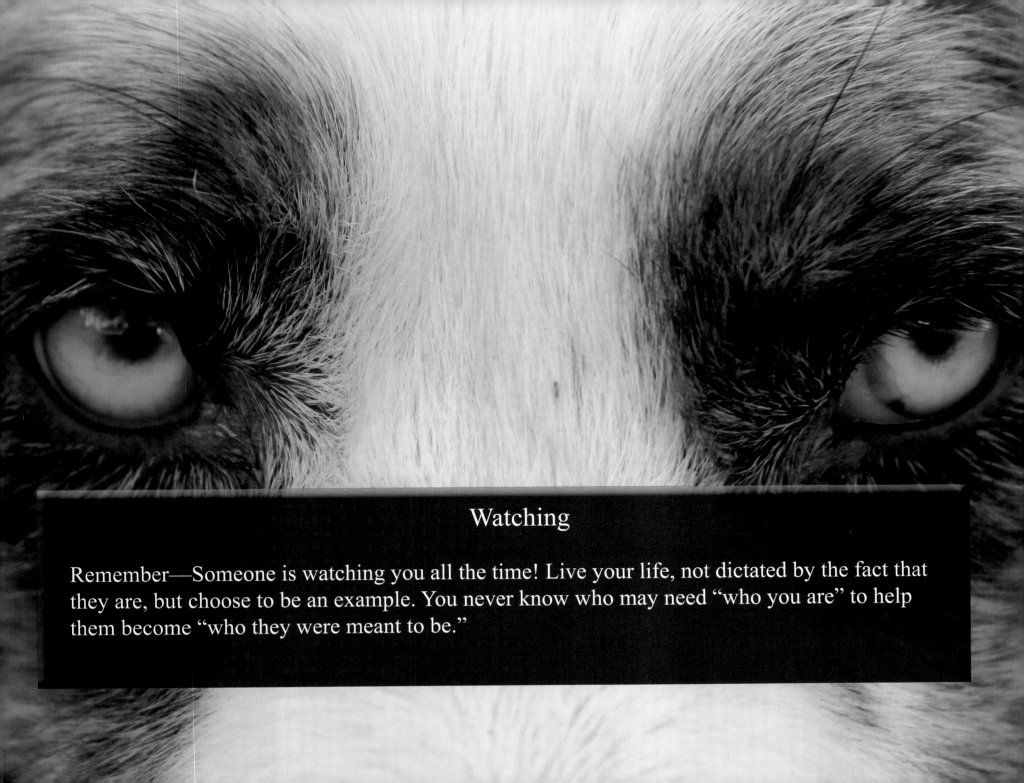

Watching

Remember—Someone is watching you all the time! Live your life, not dictated by the fact that they are, but choose to be an example. You never know who may need "who you are" to help them become "who they were meant to be."

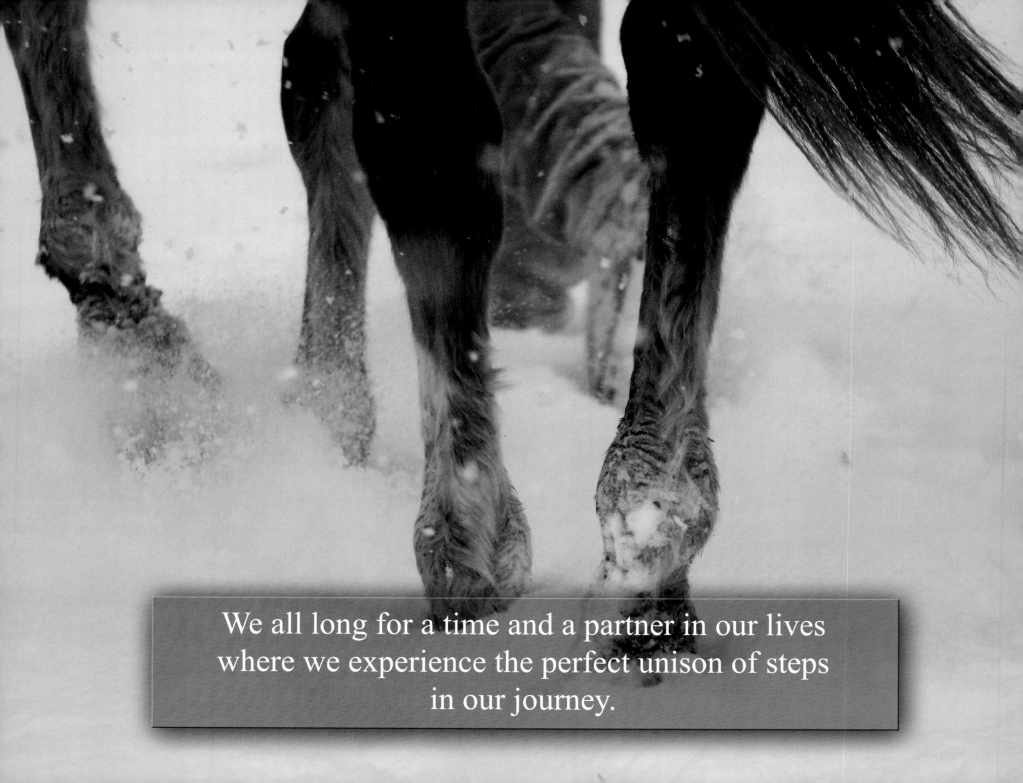

We all long for a time and a partner in our lives
where we experience the perfect unison of steps
in our journey.

God is the artist! I am here only to capture what He made for me.

But, He left his footprint to remind me that He was there.

Thank you for taking this journey with me!

A select number of the photos in this book are available in signed, limited edition matted prints. In addition, notecards and greeting cards are also available.

They can be viewed at downthebarnaisle.com.

Mr. Johnson is available for speaking engagements by contacting him at cutter0430@gmail.com.